NICOTEXT

The World's coolest baby names

Fredrik Colting
Carl-Johan Gadd
Edited by: Lara Allen
Cover by: Magnus Anderson Gadd www.tyken.se

The publisher, authors disclaim any liability that may result
from the use of the information contained in this book.
All the information in this book comes directly from experts but we
do not guarantee that the information contained herein is complete
or accurate.

www.nicotext.com
info@nicotext.com

Printed in Canada

ISBN 91-974883-1-3

So you're having a baby? Congratulations!

This book will help you find your baby a name that means something to you. I'm sure you have a couple of favourite movies that have touched you or maybe even helped cheer you up when feeling blue. Maybe you have some movie characters you look up to or maybe you just think they're really, really cool.

Browse through this book and start looking for names you like. It's arranged in alphabetical order and there is an index in the back where you can search for your favorite movies. Feel free to use the book as a source of ideas. Use both the character names and the names of the actors.

Play with the names and mix them together; half a word from this, half a word from that. See what you come up with. Good luck, mothers and fathers!

And to all you babies out there named Ace Ventura, Vincent Vega, Baby or Phoebe:
- Remember to thank us for your cool names!

"ACE" SAM ROTHSTEIN
ROBERT DE NIRO
CASINO (1995)

ACE VENTURA
JIM CARREY
ACE VENTURA: PET DETECTIVE (1994)

Ace Ventura: Pet Detective
The original screenplay for this film was more of an action movie than a comedy. The screenplay was apparently so bad, no actor would take it, and the writers resorted to then little known comedian Jim Carrey. Carrey also hated it, but agreed to co-write a new version of the script that turned the film into a hilarious slap-stick comedy.

ACHILLES
BRAD PITT
TROY (2004)

ADRIAN CRONAUER
ROBIN WILLIAMS
GOOD MORNING, VIETNAM (1987)

AGAMEMNON
BRIAN COX
TROY (2004)

AL BUNDY
ED O´NEILL
MARRIED... WITH CHILDREN (1987-1997)

ALEX P. KEATON
MICHAEL J. FOX
FAMILY TIES (1982)

ALEXANDER "XANDER" HARRIS
NICHOLAS BRENDON
BUFFY THE VAMPIRE SLAYER (1997-2003)

ALEXANDER DE LARGE
MALCOLM MCDOWELL
A CLOCKWORK ORANGE (1971)

Clockwork Orange
Malcolm McDowell, to this day
hasn't visited an optician because of the mental scarring
the 'eye scene' caused him.

The writer's physical therapist, Julian, is played by David Prowse,
who in *Star Wars* is the body of Darth Vader.

AMSTERDAM VALLON
LEONARDO DICAPRIO
GANGS OF NEW YORK (2002)

ANDY DUFRESNE
TIM ROBBINS
THE SHAWSHANK REDEMPTION (1994)

ANGUS MACGYVER
RICHARD DEAN ANDERSON
MACGYVER (1985-1992)

ANIMAL MOTHER
ADAM BALDWIN
FULL METAL JACKET (1987)

APOLLO CREED
CARL WEATHERS
ROCKY (1976)

ARAGORN
VIGGO MORTENSEN
THE LORD OF THE RINGS:
THE FELLOWSHIP OF THE RING (2001)

ARCHIE LEACH
JOHN CLEESE
A FISH CALLED WANDA (1988)

ARNIE GRAPE
LEONARDO DICAPRIO
WHAT'S EATING GILBERT GRAPE (1993)

ARTHUR "FONZIE" FONZARELLI
HENRY WINKLER
HAPPY DAYS (1974-1984)

ATTICUS FINCH
GREGORY PECK
TO KILL A MOCKINGBIRD (1962)

AURIC GOLDFINGER
GERT FROBE
GOLDFINGER (1964)

AUSTIN POWERS
MIKE MYERS
AUSTIN POWERS:
INTERNATIONAL MAN OF MYSTERY (1997)

DET. AXEL FOLEY
EDDIE MURPHY
BEVERLY HILLS COP (1984)

BARBOSSA
GEOFFREY RUSH
PIRATES OF THE CARIBBEAN:
THE CURSE OF THE BLACK PEARL (2003)

BARNEY RUBBLE
RICK MORANIS
THE FLINTSTONES (1994)

BARTON FINK
JOHN TURTURRO
BARTON FINK (1991)

BATMAN/BRUCE WAYNE
MICHAEL KEATON
BATMAN (1989)

Batman Returns
Michelle Pfeiffer was cast as Catwoman years before the movie was even in production, when director Tim Burton saw her climb up the ladder during the song 'Cool Rider' in the film *Grease 2*. Burton felt her movements were very feline-like.

BENJAMIN BRADDOCK
DUSTIN HOFFMAN
THE GRADUATE (1967)

BENJAMIN FRANKLIN "HAWKEYE" PIERCE
ALAN ALDA
M*A*S*H (1972-1983)

BENJAMIN L. WILLARD
MARTIN SHEEN
APOCALYPSE NOW (1979)

Apocalypse Now
The day the surf scenes was to be filmed there were no waves,
so the FX people set explosives to create them.

BENNY BLANCO
JOHN LEGUIZAMO
CARLITO'S WAY (1993)

BERGER
TREAT WILLIAMS
HAIR (1979)

BIFF TANNEN
THOMAS F. WILSON
BACK TO THE FUTURE (1985)

BILBO BAGGINS
IAN HOLM
THE LORD OF THE RINGS:
THE FELLOWSHIP OF THE RING (2001)

Lord of the Rings

Several cast members received memorabilia from the film as gifts from Peter Jackson and his wife. Cate Blanchett received the pointed elven ears she wore in the movie, cast in bronze, because she once said the ears were one of the main reasons for her to do the film. Elijah Wood received a beautiful small box with one of the two Rings used for filming, inside it. The other ring was auctioned off shortly after the release of the film to an unknown buyer.

BILL S. PRESTON, ESQ
ALEX WINTER
BILL & TED'S BOGUS JOURNEY (1991)

BILLY
DENNIS HOPPER
EASY RIDER (1969)

BILLY MACK
BILL NIGHY
LOVE ACTUALLY (2003)

BLAKE CARRINGTON
JOHN FORSYTHE
DYNASTY (1981-1989)

"BLUTO" JOHN BLUTARSKY
JOHN BELUSHI
ANIMAL HOUSE (1978)

BO DUKE
JOHN SCHNEIDER
THE DUKES OF HAZZARD (1979-1985)

BOB HARRIS
BILL MURRAY
LOST IN TRANSLATION (2003)

BOBBY EWING
PATRICK DUFFY
DALLAS (1978-1991)

BOBBY PERU
WILLEM DAFOE
WILD AT HEART (1990)

BODHI
PATRICK SWAYZE
POINT BREAK (1991)

"BOO" ARTHUR RADLEY
ROBERT DUVALL
TO KILL A MOCKINGBIRD (1962)

BOSCO ALBERT "B.A." BARACUS
MR. T
THE A-TEAM (1983-1987)

BRAD MAJORS
BARRY BOSTWICK
THE ROCKY HORROR
PICTURE SHOW (1975)

BRIAN FLANAGAN
TOM CRUISE
COCKTAIL (1988)

BRUCE NOLAN
JIM CARREY
BRUCE ALMIGHTY (2003)

Bruce Almighty
When Bruce (Jim Carrey) and God (Morgan Freeman) are mopping the floors, God says, "Alrighty then," an obvious reference to Carrey's film, *Ace Ventura*.

"BUBBA"
BENJAMIN BUFORD BLUE
MYKELTI WILLIAMSON
FORREST GUMP (1994)

BUGSY SIEGEL
WARREN BEATTY
BUGSY (1991)

BULLITT
STEVE MCQUEEN
BULLITT (1968)

BUTCH CASSIDY
PAUL NEWMAN
BUTCH CASSIDY AND THE SUNDANCE KID (1969)

CAPTAIN VON TRAPP
CHRISTOPHER PLUMMER
THE SOUND OF MUSIC (1965)

Sound of Music
In the scene where Maria (Julie Andrews) sings "I've got Confidence," at the fountain, you can see the real Maria von Trapp through the arched-door gate.

CARL HANRATTY
TOM HANKS
CATCH ME IF YOU CAN (2002)

CARL SPACKLER
BILL MURRAY
CADDYSHACK (1980)

CARLITO BRIGANTE
AL PACINO
CARLITO'S WAY (1993)

CASTOR TROY
NICOLAS CAGE
FACE / OFF (1997)

Face/Off
The movie's original title was simply *Faceoff*, but test audiences
thought that it was a movie about hockey, so they
added the slash to name it *Face/Off*.

CHANDLER BING
MATTHEW PERRY
FRIENDS (1994-2004)

CHARLES FOSTER KANE
ORSON WELLES
CITIZEN KANE (1941)

CHARLIE CROKER
MICHAEL CAINE
THE ITALIAN JOB (1969)

CLARENCE WORLEY
CHRISTIAN SLATER
TRUE ROMANCE (1993)

CLARK KENT
SUPERMAN/ KAL-EL
CHRISTOPHER REEVE
SUPERMAN · THE MOVIE (1978)

Superman
A "swim cup" was sewn into the Superman costume to prevent
Christopher Reeve's "private parts" from bouncing around
on screen.

CLAUDE
JOHN SAVAGE
HAIR (1979)

CLYDE BARROW
WARREN BEATTY
BONNIE AND CLYDE (1967)

COMMANDER SPOCK
LEONARD NIMOY
STAR TREK (1966)

COMMODUS
JOAQUIN PHOENIX
GLADIATOR (2000)

Gladiator

At the beginning of the movie, Maximus and Quintus say "Strength and Honour". This line was not originally in the script. Russell Crowe learned it while at school, and presented it to Ridley Scott, who thought it sounded cool and told him to use it in the film.

COSMO BROWN
DONALD O'CONNOR
SINGIN' IN THE RAIN (1952)

Singin´in the Rain
When Gene Kelly performs the title tune, the falling rain isn't all water; in order to show up on film, the water was mixed with milk.

COSMO KRAMER
MICHAEL RICHARDS
SEINFELD (1990-1998)

CYCLOPS/
SCOTT SUMMERS
JAMES MARSDEN
X-MEN (2000)

DADDY WARBUCKS
ALBERT FINNEY
ANNIE (1982)

DANGER MOUSE
DAVID JASON
DANGER MOUSE (1981-1987)

DANIEL "DAN" CONNER
JOHN GOODMAN
ROSEANNE (1988-1997)

DANIEL LARUSSO
RALPH MACCHIO
THE KARATE KID (1984)

DANNY OCEAN
GEORGE CLOONEY
OCEAN'S ELEVEN (2001)

DANNY WILDE
TONY CURTIS
THE PERSUADERS (1971-1972)

DANNY ZUKO
JOHN TRAVOLTA
GREASE (1978)

DARYL VAN HORNE
JACK NICHOLSON
THE WITCHES OF EASTWICK (1987)

DAVE STARSKY
PAUL MICHAEL GLASER
STARSKY AND HUTCH (1975-1979)

DETECTIVE DAVID MILLS
BRAD PITT
SE7EN (1995)

Seven
In an early scene when Brad Pitt (as Detective David Mills) and
Morgan Freeman (as Detective William Somerset) walk down
the street, all the building addresses begin with 7.

DEAN KEATON
GABRIEL BYRNE
THE USUAL SUSPECTS (1995)

The Usual Suspects
Almost nobody in the cast knew which character was Keyser Soze.
After the premiere, Gabriel Byrne said:
"I thought I was Keyser.Soze".

CAPT. DENNIS DEARBORN
MATTHEW MODINE
MEMPHIS BELLE (1990)

Memphis Belle
Sandra Bullock was in this movie, but all scenes containing
her were cut during editing.

DIRK DIGGLER
EDDIE ADAMS
MARK WAHLBERG
BOOGIE NIGHTS (1997)

"DIRTY" HARRY CALLAHAN
CLINT EASTWOOD
DIRTY HARRY (1971)

DOMINIC TORETTO
VIN DIESEL
THE FAST AND THE FURIOUS (2001)

The Fast and the Furious
The house where the cops work was
at one time Elizabeth Taylor's house.

DON VITO CORLEONE
MARLON BRANDO
THE GODFATHER (1971)

The Godfather
Because Marlon Brando believed that the best read was the first
one, and hence didn't read scripts ahead of time. Instead,
his lines were written on Post-Its and placed all over the sets -
including inside Robert Duval's mouth.

DONNIE BRASCO
AKA JOSEPH D. "JOE" PISTONE
JOHNNY DEPP
DONNIE BRASCO (1997)

"DOUG" DOUGLAS COUGHLIN
BRYAN BROWN
COCKTAIL (1988)

THE DUDE
JEFF BRIDGES
THE BIG LEBOWSKI (1998)

DUTCH ENGSTROM
ERNEST BORGNINE
THE WILD BUNCH (1969)

DYLAN SANDERS
DREW BARRYMORE
CHARLIE'S ANGELS (2000)

EDWARD LEWIS
RICHARD GERE
PRETTY WOMAN (1990)

EDWARD SCISSORHANDS
JOHNNY DEPP
EDWARD SCISSORHANDS (1990)

Edward Scissorhands
After his breakup with Winona Ryder, Johnny Depp had his "Winona Forever" tattoo altered to"Wino Forever"!

EL MARIACHI
ANTONIO BANDERAS
DESPERADO (1995)

ELIOT NESS
KEVIN COSTNER
THE UNTOUCHABLES (1987)

ELIOT LOUDERMILK
BOB GOLDTHWAIT
SCROOGED (1988)

ELLIOT RICHARDS
BRENDAN FRASER
BEDAZZLED (2000)

ELWOOD BLUES
DAN AYKROYD
THE BLUES BROTHERS (1980)

The Blues Brothers
Jon Landis (the director) is famous for using *"See You Next Wednesday"* in many of his films. The line is the title of his first script, which never became a feature. When Landis uses ideas from it, he pays tribute. In The *Blues Brothers,* the police car hides behind a billboard (shown for a couple seconds) advertising *"See You Next Wednesday"* right before pulling out and hitting the Good Ol' Boys' van.

EMILIO LARGO
ADOLFO CELI
THUNDERBALL (1964)

ERIC DRAVEN
BRANDON LEE
THE CROW (1994)

The Crow

Brandon Lee died during a mishap on the set. One of the scenes required a gun to be loaded, cocked, and then pointed at the camera. Because of the close range of the shot, the bullets loaded had real brass caps, but no powder. After the cut, the propsmaster dry-fired the gun to get the cock off, knocking an empty cartridge into the barrel of the gun. The next scene to be filmed involving that gun was the rape of Shelly. The gun was loaded with blanks (which usually contain double or triple the powder of a normal bullet to make a loud noise). Lee entered the set carrying a bag of groceries containing an explosive blood pack. The script called for Funboy (Michael Massee) to shoot Eric Draven (Lee) as he entered the room, triggering the blood pack. The cartridge that was stuck in the barrel blasted at Lee through the bag he was carrying, killing him. The footage of his death was destroyed without being developed. Lee was the son of martial arts legend Bruce Lee, who died under mysterious circumstances before completing *Game of Death* (1978).

ERIC FORMAN
TOPHER GRACE
THAT '70S SHOW (1998-)

ERNEST PENFOLD
TERRY SCOTT
DANGER MOUSE (1981-1987)

ERNST STAVRO BLOFELD
ANTHONY DAWSON/ERIC POHLMAN
FROM RUSSIA WITH LOVE (1963)

ETHAN EDWARDS
JOHN WAYNE
THE SEARCHERS (1956)

ETHAN HUNT
TOM CRUISE
MISSION: IMPOSSIBLE (1996)

FERRIS BUELLER
MATTHEW BRODERICK
FERRIS BUELLER'S DAY OFF (1986)

Ferris Bueller's Day Off
Jeanie's car has a license plate that reads "TBC,"
which stands for *"The Breakfast Club"* –
the title of one of director John Hughes' earlier films.

FEZ
WILMER VALDERRAMA
THAT '70S SHOW (1998-)

FORREST GUMP
TOM HANKS
FORREST GUMP (1994)

FOX MULDER
DAVID DUCHOVNY
THE X FILES (1993-2002)

FRANCIS XAVIER CROSS
BILL MURRAY
SCROOGED (1988)

"FRANCO"
FRANCIS BEGBIE
ROBERT CARLYLE
TRAINSPOTTING (1996)

FRANCISCO SCARAMANGA
CHRISTOPHER LEE
THE MAN WITH THE GOLDEN GUN (1974)

FRANK ABAGNALE JR.
LEONARDO DICAPRIO
CATCH ME IF YOU CAN (2002)

LT. FRANK DREBIN
LESLIE NIELSEN
THE NAKED GUN: FROM THE
FILES OF POLICE SQUAD! (1988)

DR. FRANK-N-FURTER
TIM CURRY
THE ROCKY HORROR
PICTURE SHOW (1975)

FRANK "T.J." MACKEY
TOM CRUISE
MAGNOLIA (1999)

FRED C. DOBBS
HUMPHREY BOGART
THE TREASURE OF THE
SIERRA MADRE (1948)

FRED FLINTSTONE
JOHN GOODMAN
THE FLINTSTONES (1994)

FREDDY KRUEGER
ROBERT ENGLUND
A NIGHTMARE ON ELM STREET (1984)

FRODO BAGGINS
ELIJAH WOOD
THE LORD OF THE RINGS:
THE FELLOWSHIP OF THE RING (2001)

GARTH ALGAR
DANA CARVEY
WAYNE'S WORLD (1992)

GEORGE BAILEY
JAMES STEWART
IT'S A WONDERFUL LIFE (1946)

GEORGE COSTANZA
JASON ALEXANDER
SEINFELD (1990-1998)

GEORGE MALLEY
JOHN TRAVOLTA
PHENOMENON (1996)

GILBERT GRAPE
JOHNNY DEPP
WHAT'S EATING GILBERT GRAPE (1993)

GORDON GEKKO
MICHAEL DOUGLAS
WALL STREET (1987)

DR. GONZO
BENICIO DEL TORO
FEAR AND LOATHING
IN LAS VEGAS (1998)

GRINCH
JIM CARREY
HOW THE GRINCH
STOLE CHRISTMAS (2000)

H.M. "HOWLING MAD"
MURDOCK
DWIGHT SCHULTZ
THE A-TEAM (1983-1987)

HAL 9000
DOUGLAS RAIN (VOICE)
2001: A SPACE ODYSSEY (1968)

2001: A Space Odyssey
If you've ever taken the time to look closely at the acronym HAL, you will notice that 'H' comes before 'I', 'A' before 'B', and 'L' before 'M'. What does that spell? IBM—one of the largest computer companies in the world.

HAN SOLO
HARRISON FORD
STAR WARS (1977)

Star Wars
Director George Lucas came up with the name for Yoda at a screenwriting seminar, where he met the Japanese screenwriter Yohikata Yoda. For Yohikata's sake I hope Lucas didn't make Yoda look like Yohikata Yoda!

HANNIBAL CHEW
JAMES HONG
BLADE RUNNER (1982)

Blade Runner
The end sequence (flying through the clouds) to the directors' cut of Blade Runner was footage that Stanley Kubrick discarded from the opening of *The Shining*.

DR. HANNIBAL LECTER
ANTHONY HOPKINS
THE SILENCE OF THE LAMBS (1991)

HARRY BURNS
BILLY CRYSTAL
WHEN HARRY MET SALLY... (1989)

HARRY DUNNE
JEFF DANIELS
DUMB & DUMBER (1994)

Dumb and Dumber

In the diner scene, the guy sitting across from Sea Bass is wearing a hat that says - "Happiness is seeing your mother-in-law's picture on a milk carton".

HARRY LIME
ORSON WELLES
THE THIRD MAN (1949)

HARRY POTTER
DANIEL RADCLIFFE
HARRY POTTER AND THE
PHILOSOPHER'S STONE (2001)

Harry Potter and the Sorcerer's Stone
Richard Harris (Dumbledore) did not want to play Professor Dumbledore until his granddaughter said "If you don't play Dumbledore, I'll never speak to you again!" So he did!

HARRY S. STAMPER
BRUCE WILLIS
ARMAGEDDON (1998)

Armageddon
Director Michael Bay had his actors write their list of demands on the papers that Bruce Willis reads from in a scene of the movie. These demands include: 1) Bringing back 8 Track tapes. 2) "You guys couldn't tell us who REALLY shot JKF?" 3) "Spending the summer in the White house." 4) "Full Emporers package' at Caesar's Palace", and 5) "No More Taxes.....Ever".

HATTORI HANZO
SONNY CHIBA
KILL BILL: VOL. 1 (2003)

DR. HEATHCLIFF "CLIFF" HUXTABLE
BILL COSBY
THE COSBY SHOW (1984-1992)

HECTOR
ERIC BANA
TROY (2004)

HOLLY MARTINS
JOSEPH COTTEN
THE THIRD MAN (1949)

HUGO DRAX
MICHAEL LONSDALE
MOONRAKER (1979)

"ICEMAN"
LT. TOM KAZANSKI
VAL KILMER
TOP GUN (1986)

THE INCREDIBLE HULK
LOU FERRIGNO
THE INCREDIBLE HULK (1978-1982)

INDIANA JONES
HARRISON FORD
RAIDERS OF THE LOST ARK (1981)

Raiders of the Lost Ark
Tom Selleck was originally cast as Indiana Jones, but was committed to *Magnum P.I.* and couldn't do the movie.

Harrison Ford badly bruised his ribs during the scene where he is dragged behind the truck. When asked if he was worried, Ford reportedly quipped: "No. If it really was dangerous, they would have filmed more of the movie first."

J. J. "JAKE" GITTES
JACK NICHOLSON
THE TWO JAKES (1990)

JACK DAWSON
LEONARDO DICAPRIO
TITANIC (1997)

JACK HORNER
BURT REYNOLDS
BOOGIE NIGHTS (1997)

JACK SPARROW
JOHNNY DEPP
PIRATES OF THE CARIBBEAN:
THE CURSE OF THE BLACK PEARL (2003)

JACK TORRANCE
JACK NICHOLSON
THE SHINING (1980)

JACK VINCENNES
KEVIN SPACEY
L.A. CONFIDENTIAL (1997)

JACQUES CLOUSEAU
PETER SELLERS
THE PINK PANTHER STRIKES AGAIN (1976)

JAKE BLUES
JOHN BELUSHI
THE BLUES BROTHERS (1980)

JAKE LA MOTTA
ROBERT DE NIRO
RAGING BULL (1980)

JAMES BOND
SEAN CONNERY
GEORGE LAZENBY
ROGER MOORE
TIMOTHY DALTON
PIERCE BROSNAN

JAMES T. KIRK
WILLIAM SHATNER
STAR TREK (1966)

JAWS
RICHARD KIEL
MOONRAKER (1979)
THE SPY WHO LOVED ME (1977)

JEAN-BAPTISTE EMANUEL ZORG
GARY OLDMAN
THE FIFTH ELEMENT (1997)

JEDEDIAH LELAND
JOSEPH COTTEN
CITIZEN KANE (1941)

JEFF SPICOLI
SEAN PENN
FAST TIMES AT RIDGEMONT HIGH (1982)

JERRY MAGUIRE
TOM CRUISE
JERRY MAGUIRE (1996)

JERRY SEINFELD
JERRY SEINFELD
SEINFELD (1990-1998)

JIM
CILLIAN MURPHY
28 DAYS LATER... (2002)

28 Days Later

The scene of an empty London was filmed very early on a weekday morning. Director Danny Boyle organized a group of very good-looking women to stop the traffic from entering the empty streets as he rightly thought drivers would be more co-operative with good looking girls than hairy men.

JIM LOVELL
TOM HANKS
APOLLO 13 (1995)

Apollo 13
In *Forrest Gump*, Lieutenant Dan (Gary Sinise) said that the day
Forrest (Tom Hanks) becomes a shrimp boat captain, he'll be an
astronaut. Later, Gary Sinise and Tom Hanks appear in
Apollo 13 together--as astronauts.

JIM STARK
JAMES DEAN
REBEL WITHOUT A CAUSE (1955)

Rebel Without A Cause
Approximately two hours before his fatal car crash,
James Dean received a speeding ticket for driving 75 miles
per hour in a 45 mile per hour zone. He shrugged it off
and sped off down the highway.

JIMMY CONWAY
ROBERT DE NIRO
GOODFELLAS (1990)

DET. JIMMY
"POPEYE" DOYLE
GENE HACKMAN
THE FRENCH CONNECTION (1971)

JIMMY RABBITTE
ROBERT ARKINS
THE COMMITMENTS (1991)

JOE GIDEON
ROY SCHEIDER
ALL THAT JAZZ (1979)

JOEY TRIBBIANI
MATT LEBLANC
FRIENDS (1994-2004)

JOHN DOE
KEVIN SPACEY
SE7EN (1995)

JOHN "HANNIBAL" SMITH
GEORGE PEPPARD
THE A-TEAM (1983-1987)

JOHN J. RAMBO
SYLVESTER STALLONE
FIRST BLOOD (1982)

JOHN KEATING
ROBIN WILLIAMS
DEAD POETS SOCIETY (1989)

JOHN MCCLANE
BRUCE WILLIS
DIE HARD (1988)

Die Hard
The Nakatomi Building, the setting of the movie,
is actually the Fox headquarters.

JOHN ROSS "J.R." EWING, JR.
LARRY HAGMAN
DALLAS (1978-1991)

JOHN SHAFT
RICHARD ROUNDTREE
SHAFT (1971)

JOHNNY CASTLE
PATRICK SWAYZE
DIRTY DANCING (1987)

JOHNNY UTAH
KEANU REEVES
POINT BREAK (1991)

PVT. JOKER
MATTHEW MODINE
FULL METAL JACKET (1987)

JONATHAN QUAYLE HIGGINS III
JOHN HILLERMAN
MAGNUM, P.I. (1980-1988)

JOR-EL
MARLON BRANDO
SUPERMAN · THE MOVIE (1978)

JUDAH BEN-HUR
CHARLTON HESTON
BEN-HUR (1959)

JULES WINNFIELD
SAMUEL L. JACKSON
PULP FICTION (1994)

JULIUS BENEDICT
ARNOLD SCHWARZENEGGER
TWINS (1988)

DR. JULIUS NO
JOSEPH WISEMAN
DR. NO (1962)

K.I.T.T.
(KNIGHT INDUSTRIES TWO THOUSAND)
WILLIAM DANIELS
KNIGHT RIDER (1982-1986)

KANANGA/MR BIG
YAPHET KOTTO
LIVE AND LET DIE (1973)

KEN HUTCHINSON
OWEN WILSON
STARSKY & HUTCH (2004)

KEN "HUTCH" HUTCHINSON
DAVID SOUL
STARSKY AND HUTCH (1975-1979)

KNOX OVERSTREET
JOSH CHARLES
DEAD POETS SOCIETY (1989)

LEE
BRUCE LEE
ENTER THE DRAGON (1973)

Enter the Dragon
In a scene where Bruce Lee encounters several ninja-type guards, one of the men is Jackie Chan. Bruce Lee has him in a headlock while kicking another guy. In real life, Jackie Chan was hurt pretty bad with a neck injury.

LEGOLAS GREENLEAF
ORLANDO BLOOM
THE LORD OF THE RINGS: THE
FELLOWSHIP OF THE RING (2001)

LESTER BURNHAM
KEVIN SPACEY
AMERICAN BEAUTY (1999)

LEX LUTHOR
GENE HACKMAN
SUPERMAN - THE MOVIE (1978)

LIEUTENANT COLUMBO
PETER FALK
COLUMBO (1971)

LLOYD CHRISTMAS
JIM CARREY
DUMB & DUMBER (1994)

Dumb and Dumber
If Lloyd Christmas (Jim Carrey) married Mary
(Lauren Holly), her name would be Mary Christmas.

LORD BRETT SINCLAIR
ROGER MOORE
THE PERSUADERS (1971-1972)

LT. LOTHAR ZOGG
JAMES EARL JONES
DR. STRANGELOVE OR: HOW I LEARNED
TO STOP WORRYING AND LOVE
THE BOMB (1964)

Dr. Strangelove

In the scene where Slim Pickens is going over the survival-gear, he says "a fella could have quite a good time in Vegas with all of this". The line was originally written as: "a fella could have quite a good time in Dallas with all of this". They changed the city name because the release followed the assassination of Presdient John F. Kennedy, and the studio didn't want the association.

LUKE DUKE
TOM WOPAT
THE DUKES OF HAZZARD (1979-1985)

LUKE SKYWALKER
MARK HAMILL
STAR WARS (1977)

The Empire Strikes Back
Out of all the cast of *The Empire Strikes Back*, Mark Hamill, David Prowse and James Earl Jones were the only ones that knew Darth Vader was Luke's father. George Lucas made sure no other actors knew, so the secret wouldn't be revealed.

MARTIN BRODY
ROY SCHEIDER
JAWS (1975)

Jaws
The mechanical shark in the movie was nicknamed Bruce--after Spielberg's lawyer.

"MAD MAX" ROCKATANSKY
MEL GIBSON
MAD MAX (1979)

MAGNETO/ERIK LEHNSHERR
IAN MCKELLEN
X-MEN (2000)

MAJOR KORBEN DALLAS
BRUCE WILLIS
THE FIFTH ELEMENT (1997)

DET. MARCUS BURNETT
MARTIN LAWRENCE
BAD BOYS (1995)

MARK "RENT BOY" RENTON
EWAN MCGREGOR
TRAINSPOTTING (1996)

MARSELLUS WALLACE
VING RHAMES
PULP FICTION (1994)

MARTIN RIGGS
MEL GIBSON
LETHAL WEAPON (1987)

MARTINI
DANNY DEVITO
ONE FLEW OVER THE
CUCKOO'S NEST (1975)

MARTY MCFLY
CALVIN MARTY KLEIN
MICHAEL J. FOX
BACK TO THE FUTURE (1985)

"MAVERICK"
LT. PETE MITCHELL
TOM CRUISE
TOP GUN (1986)

MAX ZORIN
CHRISTOPER WALKEN
A VIEW TO A KILL (1985)

MAXIMUS
RUSSELL CROWE
GLADIATOR (2000)

MELVIN UDALL
JACK NICHOLSON
AS GOOD AS IT GETS (1997)

MICHAEL "MIKE" BRADY
ROBERT REED
THE BRADY BUNCH (1969-1974)

MICHAEL CORLEONE
AL PACINO
THE GODFATHER (1972)

MICHAEL J.
"CROCODILE" DUNDEE
PAUL HOGAN
CROCODILE DUNDEE (1986)

MICHAEL KELSO
ASHTON KUTCHER
THAT '70S SHOW (1998-)

MICHAEL KNIGHT
DAVID HASSELHOFF
KNIGHT RIDER (1982-1986)

MICHAEL MYERS
TONY MORAN
HALLOWEEN (1978)

MICKEY KNOX
WOODY HARRELSON
NATURAL BORN KILLERS (1994)

DET. MIKE LOWREY
WILL SMITH
BAD BOYS (1995)

MILES MASSEY
GEORGE CLOONEY
INTOLERABLE CRUELTY (2003)

MILTON WARDEN
BURT LANCASTER
FROM HERE TO ETERNITY (1953)

MR. BLONDE/VIC
MICHAEL MADSEN
RESERVOIR DOGS (1992)

MR. MIYAGI
PAT MORITA
THE KARATE KID (1984)

MR. ORANGE/FREDDY
TIM ROTH
RESERVOIR DOGS (1992)

MR. PINK
STEVE BUSCEMI
RESERVOIR DOGS (1992)

Reservoir Dogs

Tarantino was going to film *Reservoir Dogs* in black & white with him and his friends playing the lead roles. However, his friend Lawrence Bender was able to get in touch with someone who knew Harvey Keitel, managing to get Keitel to read the script. Keitel was so impressed, he immediately signed on, even helping raise the money to film it. Keitel's participation made it possible to attract other well-known character actors to the movie.

MR. WHITE/LARRY
HARVEY KEITEL
RESERVOIR DOGS (1992)

NEIL MCCAULEY
ROBERT DE NIRO
HEAT (1995)

NEMO
ALEXANDER GOULD (VOICE)
FINDING NEMO (2003)

Finding Nemo
The name of the large shark who goes crazy in this film is Bruce -
the same nickname given to the robotic shark used in Jaws.

NEO
KEANU REEVES
THE MATRIX (1999)

NICE GUY EDDIE
CHRIS PENN
RESERVOIR DOGS (1992)

NICKY SANTORO
JOE PESCI
CASINO (1995)

NORMAN BATES
ANTHONY PERKINS
PSYCHO (1960)

Psycho
In the infamous shower scene, the reason Janet Lee seems so
scared and surprised is that she actually is! For added effect,
Hitchcock turned the water in the shower to freezing
cold when "Mrs. Bates" attacked her.

ODD JOB
HAROLD SAKATA
GOLDFINGER (1964)

PARIS
ORLANDO BLOOM
TROY (2004)

DR. PETER BLOOD
ERROL FLYNN
CAPTAIN BLOOD (1935)

PETER PARKER
TOBEY MAGUIRE
SPIDER-MAN (2002)

Spider-man

The director Sam Raimi puts his 1973 Oldsmobile Delta 88 in all of his films. In *Spider-man,* it's the car the grandfather drives

DR. PETER VENKMAN
BILL MURRAY
GHOSTBUSTERS (1984)

Ghostbusters

Bill Murray's part in Ghostbusters was originally written for John Belushi, who unfortunately died shortly before the casting.

PHILIP HENSLOWE
GEOFFREY RUSH
SHAKESPEARE IN LOVE (1998)

PHILIP MARLOWE
HUMPHREY BOGART
THE BIG SLEEP (1946)

QUINTUS ARRIUS
JACK HAWKINS
BEN-HUR (1959)

Ben-Hur

During filming of the chariot race, one of the expensive cameras (with a cost of $100,000 in 1958) was completely destroyed when a chariot ran over it. The footage right up to the camera's destruction was used in the final film.

"QUIZ KID" DONNIE SMITH
WILLIAM H. MACY
MAGNOLIA (1999)

RANDLE PATRICK MCMURPHY
JACK NICHOLSON
ONE FLEW OVER THE
CUCKOO'S NEST (1975)

RAOUL DUKE
JOHNNY DEPP
FEAR AND LOATHING IN LAS VEGAS (1998)

RATSO RIZZO
DUSTIN HOFFMAN
MIDNIGHT COWBOY (1969)

RAYMOND BABBITT
DUSTIN HOFFMAN
RAIN MAN (1988)

REMINGTON STEELE
PIERCE BROSNAN
REMINGTON STEELE (1982)

RHETT BUTLER
CLARK GABLE
GONE WITH THE WIND (1939)

Gone With The Wind
Vivien Leigh received only $15,000 for her performance
as Scarlett O'Hara in *Gone With the Wind*.

RICARDO TUBBS
PHILIP MICHAEL THOMAS
MIAMI VICE (1984-1989)

RICHARD "RICHIE" CUNNINGHAM
RON HOWARD
HAPPY DAYS (1974-1984)

RICHARD GECKO
QUENTIN TARANTINO
FROM DUSK TILL DAWN (1996)

From Dusk til Dawn
When everyone is in the same hotel room, George Clooney says,"'Ramblers, let get rambling" - the same line used in the beginning of *Reservoir Dogs*.

DR. RICHARD KIMBLE
HARRISON FORD
THE FUGITIVE (1993)

RICK BLAINE
HUMPHREY BOGART
CASABLANCA (1942)

Casablanca
Bogart never said, and neither did anyone else, "Play it again, Sam".
What he did say was "Play it, Sam".

RICK DECKARD
HARRISON FORD
BLADE RUNNER (1982)

RICKY FITTS
WES BENTLEY
AMERICAN BEAUTY (1999)

ROBERT KINCAID
CLINT EASTWOOD
THE BRIDGES OF MADISON COUNTY (1995)

ROCKHOUND
STEVE BUSCEMI
ARMAGEDDON (1998)

ROCKY BALBOA
SYLVESTER STALLONE
ROCKY (1976)

Rocky

Sylvester Stallone wrote the screenplay for *Rocky* in only 3 days. According to Stallone, he was offered over $400,000 for the film rights to his script, but the studios wanted Ryan O'Neil to star, as ludicrous as that may seem. Sly held out, determined to star. The studios eventually relented, giving Sly $50,000 and 10% of the movies gross. The movie went on to gross over 150 million - making Stallone a very wealthy man.

ROGER O. THORNHILL
CARY GRANT
NORTH BY NORTHWEST (1959)

ROGER "VERBAL" KINT
KEVIN SPACEY
THE USUAL SUSPECTS (1995)

ROGER MURTAUGH
DANNY GLOVER
LETHAL WEAPON (1987)

ROGER VAN ZANT
WILLIAM FICHTNER
HEAT (1995)

ROMEO MONTAGUE
LEONARDO DICAPRIO
ROMEO + JULIET (1996)

ROSS GELLER
DAVID SCHWIMMER
FRIENDS (1994-2004)

RUSSELL HAMMOND
BILLY CRUDUP
ALMOST FAMOUS (2000)

ROY NEARY
RICHARD DREYFUSS
CLOSE ENCOUNTERS OF
THE THIRD KIND (1977)

Close Encounters of the Third Kind
When the Mother-Ship passes over the Devil's Tower near the end of the film, R2-D2 from *Star Wars* can be seen hanging upside down from the ship.

SAILOR
NICOLAS CAGE
WILD AT HEART (1990)

SALLY TOMATO
ALAN REED
BREAKFAST AT TIFFANY'S (1961)

SAM "MAYDAY" MALONE
TED DANSON
CHEERS (1982-1993)

SAM BALDWIN
TOM HANKS
SLEEPLESS IN SEATTLE (1993)

SAM SPADE
HUMPHREY BOGART
THE MALTESE FALCON (1941)

SAM SWEET/STAN SWEET
BEN STILLER
THE CABLE GUY (1996)

The Cable Guy
During filming of the scene of the Cable Guy (Jim Carrey) playing basketball, Carrey admitted he could barely dribble a basketball, much less make a basket. Director Ben Stiller had Carrey mime the action without a ball and visual effects technicians added the basketball in postproduction.

SCOTT EVIL
SETH GREEN
AUSTIN POWERS: INTERNATIONAL
MAN OF MYSTERY (1997)

SEAN ARCHER
JOHN TRAVOLTA
FACE / OFF (1997)

SETH
NICOLAS CAGE
CITY OF ANGELS (1998)

SETH GECKO
GEORGE CLOONEY
FROM DUSK TILL DAWN (1996)

SEYMOUR KRELBORN
RICK MORANIS
LITTLE SHOP OF HORRORS (1986)

SIMON TEMPLAR
ROGER MOORE
THE SAINT (1962-1969)

SMOKEY LONESOME
TIM SCOTT
FRIED GREEN TOMATOES (1991)

SNAKE PLISSKEN
KURT RUSSELL
ESCAPE FROM NEW YORK (1981)

SONNY BLACK
MICHAEL MADSEN
DONNIE BRASCO (1997)

SONNY CORLEONE
JAMES CAAN
THE GODFATHER (1972)

SONNY CROCKETT
DON JOHNSON
MIAMI VICE (1984-1989)

SPARTACUS
KIRK DOUGLAS
SPARTACUS (1960)

STANLEY IPKISS
JIM CARREY
THE MASK (1994)

STANLEY KOWALSKI
MARLON BRANDO
A STREETCAR NAMED DESIRE (1951)

STEVE BOLANDER
RON HOWARD
AMERICAN GRAFFITI (1973)

STEVE STIFLER
SEANN WILLIAM SCOTT
AMERICAN PIE (1999)

STEVEN "STEVE" HILLER
WILL SMITH
INDEPENDENCE DAY (1996)

Independence Day

If you listen carefully in Will Smiths home, you can hear the opening theme to *The Fresh Prince of Bel Air*, which is incidentally performed by the man himself.

TED LOGAN
KEANU REEVES
BILL & TED'S BOGUS JOURNEY (1991)

TEEHEE
JULIUS HARRIS
LIVE AND LET DIE (1973)

TEMPLETON "FACEMAN" PECK #2
DIRK BENEDICT
THE A-TEAM (1983-1987)

THEO KOJAK
TELLY SAVALAS
KOJAK (1973)

THEODORE ALOYSIUS "THEO" HUXTABLE
MALCOLM-JAMAL WARNER
THE COSBY SHOW (1984-1992)

THING
CHRISTOPHER HART
THE ADDAMS FAMILY (1991)

THOMAS SULLIVAN MAGNUM III
TOM SELLECK
MAGNUM, P.I. (1980-1988)

TIGER TANAKA
TETSURO TAMBA
YOU ONLY LIVE TWICE (1967)

TOMMY DEVITO
JOE PESCI
GOODFELLAS (1990)

"TONY"
ANTONIO MONTANA
AL PACINO
SCARFACE (1983)

TONY BARETTA
ROBERT BLAKE
BARETTA (1975-1978)

TONY MANERO
JOHN TRAVOLTA
SATURDAY NIGHT FEVER (1977)

TRAVIS BICKLE
ROBERT DE NIRO
TAXI DRIVER (1976)

Taxi Driver
Robert De Niro got a real taxi driver's license and drove a genuine
New York taxi in order to fully get into character - and he still had
time to shoot another movie called *1900*.

TRUMAN BURBANK
JIM CARREY
THE TRUMAN SHOW (1998)

TYLER DURDEN
BRAD PITT
FIGHT CLUB (1999)

UNCLE FESTER
GORDON CRAVEN
CHRISTOPHER LLOYD
THE ADDAMS FAMILY (1991)

VINCE EVERETT
ELVIS PRESLEY
JAILHOUSE ROCK (1957)

VINCENT BENEDICT
DANNY DEVITO
TWINS (1988)

LT. VINCENT HANNA
AL PACINO
HEAT (1995)

VINCENT VEGA
JOHN TRAVOLTA
PULP FICTION (1994)

VIRGIL "BUD" BRIGMAN
ED HARRIS
THE ABYSS (1989)

VIRGIL HILTS
A.K.A. THE COOLER KING
STEVE MCQUEEN
THE GREAT ESCAPE (1963)

VIRGIL TIBBS
SIDNEY POITIER
IN THE HEAT OF THE NIGHT (1967)

WAYNE CAMPBELL
MIKE MYERS
WAYNE'S WORLD (1992)

WILBUR GREY
LOU COSTELLO
BUD ABBOTT LOU COSTELLO MEET
FRANKENSTEIN (1948)

"That was the best ice cream soda I ever tasted . . ."
--last words, Lou Costello, March 3, 1959

WALTER E. KURTZ
MARLON BRANDO
APOCALYPSE NOW (1979)

Apocalypse Now
The brother of Christopher Walken appears in this movie.
His name is Glenn Walken and plays the role of Lt. Carlsen.
It is the only movie he has ever appeared in.

WILL HUNTING
MATT DAMON
GOOD WILL HUNTING (1997)

WILL SHAKESPEARE
JOSEPH FIENNES
SHAKESPEARE IN LOVE (1998)

WILL TURNER
ORLANDO BLOOM
PIRATES OF THE CARIBBEAN:
THE CURSE OF THE BLACK PEARL (2003)

WILLIAM "WILLIE" TANNER
MAX WRIGHT
ALF (1986-1990)

WILLIAM CUTTING
DANIEL DAY-LEWIS
GANGS OF NEW YORK (2002)

WILLIAM THACKER
HUGH GRANT
NOTTING HILL (1999)

WILLIAM WALLACE
MEL GIBSON
BRAVEHEART (1995)

WILLY WONKA
GENE WILDER
WILLY WONKA & THE
CHOCOLATE FACTORY (1971)

WOLVERINE
LOGAN
HUGH JACKMAN
X-MEN (2000)

ZACH
MICHAEL DOUGLAS
A CHORUS LINE (1985)

A Chorus Line
Michael Douglas' dad, Kirk, originally bought the movie rights, but by the time he got to film it, he was too old for the part of Zach.

Girls

ADRIAN
TALIA SHIRE
ROCKY (1976)

ALABAMA WHITMAN
PATRICIA ARQUETTE
TRUE ROMANCE (1993)

ALEX MUNDAY
LUCY LIU
CHARLIE'S ANGELS (2000)

ALEX OWENS
JENNIFER BEALS
FLASHDANCE (1983)

ALICE
KATHRYN BEAUMONT (VOICE)
ALICE IN WONDERLAND (1951)

Alice in Wonderland
Lewis Carroll was a heavy opium user at the time he wrote *Alice in Wonderland and Her Adventures Through the Looking Glass,* so it is likely that the legendary drugs references of the film and book are, for once, real.

ALLY MCBEAL
CALISTA FLOCKHART
ALLY MCBEAL (1997-2002)

ALOTTA FAGINA
FABIANA UDENIO
AUSTIN POWERS: INTERNATIONAL
MAN OF MYSTERY (1997)

ANGELA GIOBERTI CHANNING
ERIKSON STAVROS AGRETTI
JANE WYMAN
FALCON CREST (1981-1990)

ANN DARROW
FAY WRAY
KING KONG (1933)

ANNA LEONOWENS
JODIE FOSTER
ANNA AND THE KING (1999)

ANNA SCOTT
JULIA ROBERTS
NOTTING HILL (1999)

ANNIE HALL
DIANE KEATON
ANNIE HALL (1977)

ANNIE REED
MEG RYAN
SLEEPLESS IN SEATTLE (1993)

ARIEL
JODI BENSON (VOICE)
THE LITTLE MERMAID (1989)

The Little Mermaid
In the beginning scene as a crowd awaits the entrance of King
Neptune, in the crowd are Goofy, Mickey Mouse and Donald Duck,
eating popcorn. In every single Disney movie made after
Walt Disney died, there is a hidden Mickey.

AUDREY
ELLEN GREENE
LITTLE SHOP OF HORRORS (1986)

AUDREY PARIS
LELAND PALMER
ALL THAT JAZZ (1979)

AURORA GREENWAY
SHIRLEY MACLAINE
TERMS OF ENDEARMENT (1983)

"BABY"
FRANCES HOUSEMAN
JENNIFER GREY
DIRTY DANCING (1987)

BETTY RIZZO
STOCKARD CHANNING
GREASE (1978)

BETTY RUBBLE
ROSIE O'DONNELL
THE FLINTSTONES (1994)

BIBI DAHL
LYNN-HOLLY JOHNSON
FOR YOUR EYES ONLY (1981)

For Your Eyes Only
One of the bathing beauties in this classic Bond flick was actually a man. After completing the necessary surgeries, s/he began a lucrative modeling and acting career, getting her big break in *For Your Eyes Only*. Shortly after the film was released, a British news tabloid 'outed' her as a transsexual. Her name was Caroline Cossey.

BLANCHE DUBOIS
VIVIEN LEIGH
A STREETCAR NAMED DESIRE (1951)

BONNIE PARKER
FAYE DUNAWAY
BONNIE AND CLYDE (1967)

THE BRIDE
BEATRIX KIDDO
UMA THURMAN
KILL BILL: VOL. 1-2 (2003)

Kill Bill
The yellow suit Uma wears is a replica of the
Bruce Lee outfit in *Game of Death*.

BUFFY SUMMERS
SARAH MICHELLE GELLAR
BUFFY THE VAMPIRE SLAYER
(1997-2003)

BUNNY SMITH
LANA TURNER
WEEK-END AT THE WALDORF (1945)

BUNNY WATSON
KATHARINE HEPBURN
DESK SET (1957)

CAESONIA
HELEN MIRREN
CALIGOLA (1979)

CANDY CAMERON
VERONICA LAKE
ISN'T IT ROMANTIC? (1948)

CAROL TYLER-MARTIN-BRADY
FLORENCE HENDERSON
THE BRADY BUNCH (1969-1974)

CARRIE BRADSHAW
SARAH JESSICA PARKER
SEX AND THE CITY (1998-2004)

CARRIE WHITE
SISSY SPACEK
CARRIE (1976)

Carrie

Stephen King is the author or the book *Carrie* which came out in 1974. It was his first novel. King had thrown the first pages of the story in the garbage, but his wife rescued them, urging him to finish the work. Signet paid $400,000 for paperback rights to it.

CHARLOTTE
SCARLETT JOHANSSON
LOST IN TRANSLATION (2003)

CHARLOTTE YORK
KRISTIN DAVIS
SEX AND THE CITY (1998-2004)

DR. CHRISTMAS JONES
DENISE RICHARDS
THE WORLD IS NOT ENOUGH (1999)

CINDY LOU WHO
TAYLOR MOMSEN
HOW THE GRINCH STOLE CHRISTMAS (2000)

CLAIRE STANDISH
MOLLY RINGWALD
THE BREAKFAST CLUB (1985)

The Breakfast Club
The school used in *The Breakfast Club* is the same
school used in *Ferris Bueller's Day Off*.

CLARICE STARLING
JODIE FOSTER
THE SILENCE OF THE LAMBS (1991)

CLEOPATRA
ELIZABETH TAYLOR
CLEOPATRA (1963)

CORDELIA CAMERON
AVA GARDNER
RIDE, VAQUERO! (1953)

CORIE BRATTER
JANE FONDA
BAREFOOT IN THE PARK (1967)

DAISY DUKE
CATHERINE BACH
THE DUKES OF HAZZARD (1979-1985)

DANA SCULLY
GILLIAN ANDERSON
THE X FILES (1993-2002)

DENISE HUXTABLE KENDALL
LISA BONET
THE COSBY SHOW (1984-1992)

DIANE CHAMBERS
SHELLEY LONG
CHEERS (1982-1993)

DOLORES
JOANNA CASSIDY
WHO FRAMED ROGER RABBIT (1988)

DOLORES "LOLITA" HAZE
SUE LYON
LOLITA (1962)

DOROTHY DODGE
VERONICA LAKE
OUT OF THIS WORLD (1945)

DOROTHY GALE
JUDY GARLAND
THE WIZARD OF OZ (1939)

Wizard of Oz

At the start of the "We're Off to See the Wizard" sequence, a disturbance occurs in the trees. It was rumored to be one of the crew hanging himself, but in fact it was an animal handler recapturing an escaped animal.

L. Frank Baum he came up with the name Oz while looking at his filing cabinet, whose drawers were labeled 'A-N' and 'O-Z'.

DOROTHY VALENS
ISABELLA ROSSELLINI
BLUE VELVET (1986)

EMILY MONROE NORTON KANE
RUTH WARRICK
CITIZEN KANE (1941)

EMMELINE
BROOKE SHIELDS
THE BLUE LAGOON (1980)

The Blue Lagoon
Brooke Shields spent a lot of time standing and walking in a trench beside Chris Atkins so that she wouldn't tower over him in the scenes they had together.

ELAINE BENES
JULIA LOUIS-DREYFUS
SEINFELD (1990-1998)

ELEKTRA NATCHIOS
JENNIFER GARNER
DAREDEVIL (2003)

Daredevil
In the scene where young Matt (Daredevil) is learning to use his other senses, he stops an old man before he walks onto a busy street. The man he saved was Stan Lee, the creator of *Daredevil* as well as *Spiderman* and the *X-Men*.

ELIZA DOOLITTLE
AUDREY HEPBURN
MY FAIR LADY (1964)

ELIZABETH SWANN
KEIRA KNIGHTLEY
PIRATES OF THE CARIBBEAN:
THE CURSE OF THE BLACK PEARL (2003)

DR. ELLIE SATTLER
LAURA DERN
JURASSIC PARK (1993)

Jurassic Park
The sounds the dinosaurs made were a combination of animal noises. For instance, dolphins were used for some of the raptor noises, and a rattle snake for the rattling sound of the acid spitting dino.

ERIN BROCKOVICH
JULIA ROBERTS
ERIN BROCKOVICH (2000)

Erin Brockovich
During the restaurant scene, Erin (Julia Roberts) and her three
children are dining while a waitress takes their order.
The waitress is the real Erin Brockovich, and for a joke,
the name on her name tag is "Julia".

ETHEL HALLOWAY
RITA HAYWORTH
TALES OF MANHATTAN (1942)

EULA GOODNIGHT
KATHARINE HEPBURN
ROOSTER COGBURN (1975)

EVE WHITE/EVE BLACK/JANE
JOANNE WOODWARD
THE THREE FACES OF EVE (1957)

EVA LOVELACE
KATHARINE HEPBURN
MORNING GLORY (1933)

EVELYN CROSS MULWRAY
FAYE DUNAWAY
CHINATOWN (1974)

FELICITY SHAGWELL
HEATHER GRAHAM
AUSTIN POWERS:
THE SPY WHO SHAGGED ME [1999]

Austin Powers: the Spy Who Shagged Me
The song 'Just the Two of Us' was written by Mike Myers' wife in
5 minutes. It's a parody of the same titled song by Bill Withers.

FLORA "SISSY" GOFORTH
SHIRLEY TEMPLE
BOOM [1968]

FRAN KUBELIK
SHIRLEY MACLAINE
THE APARTMENT [1960]

GINGER MCKENNA
SHARON STONE
CASINO (1995)

GEORGIA LORRISON
LANA TURNER
THE BAD AND THE BEAUTIFUL (1952)

GERTIE
DREW BARRYMORE
E.T. THE EXTRA-TERRESTRIAL (1982)

E.T.
The voice of E.T. was created by a 60 year old woman named
Marin County who said the lines without her false teeth.

GOLDE
NORMA CRANE
FIDDLER ON THE ROOF (1971)

DR. HOLLY GOODHEAD
LOIS CHILES
MOONRAKER (1979)

HOLLY GOLIGHTLY
AUDREY HEPBURN
BREAKFAST AT TIFFANY'S (1961)

HONEY BUNNY/ YOLANDA
AMANDA PLUMMER
PULP FICTION (1994)

Pulp Fiction
The Buddy Holly waiter in Jack Rabbit Slims is played by Steve
Buscemi, who starred as Mr. Pink in *Reservoir Dogs*.
Mr. Pink refused to tip waitresses.

HONEY RYDER
URSULA ANDRESS
DR.NO (1962)

IDA SESSIONS
DIANE LADD
CHINATOWN (1974)

IDGIE THREADGOODE
MARY STUART MASTERSON
FRIED GREEN TOMATOES (1991)

IMELDA QUIRKE
ANGELINE BALL
THE COMMITMENTS (1991)

ILSA LUND LASZLO
INGRID BERGMAN
CASABLANCA (1942)

Casablanca
Ronald Reagan and Ann Sheridan were originally cast
for the lead roles in Casablanca.

JANE SPENCER
PRISCILLA PRESLEY
THE NAKED GUN: FROM THE
FILES OF POLICE SQUAD! (1988)

JANET WEISS
SUSAN SARANDON
THE ROCKY HORROR PICTURE SHOW (1975)

PRINCESS JASMINE (VOICE)
LINDA LARKIN
ALADDIN (1992)

Aladdin
When Jasmine's father is building the tower of plastic animals,
to the left, in about the middle is the Beast from the movie
Beauty and the Beast - another Disney movie.

JORDAN MOONEY
ELISABETH SHUE
COCKTAIL (1988)

JULIET CAPULET
CLAIRE DANES
ROMEO + JULIET (1996)

KAY MINIVER
GREER GARSON
MRS. MINIVER (1942)

Mrs. Miniver
Greer Garson's acceptance speech for winning Best Actress in Mrs. Miniver ran over a half hour - the longest acceptance speech in Academy Award history.

KISSY SUZUKI
MIE HAMA
YOU ONLY LIVE TWICE (1967)

LACE PENNAMIN
KYRA SEDGWICK
PHENOMENON (1996)

LAURIE HENDERSON
CINDY WILLIAMS
AMERICAN GRAFFITI (1973)

LAVERNE DEFAZIO
PENNY MARSHALL
LAVERNE & SHIRLEY (1976)

LEELOO
MILLA JOVOVICH
THE FIFTH ELEMENT (1997)

LINDSEY BRIGMAN
MARY ELIZABETH MASTRANTONIO
THE ABYSS (1989)

The Abyss
There were so many inquiries about the titanium wedding-band that saved Bud's life that some enterprising individual started selling them and became quite wealthy doing so.

LILI VON SHTUPP
MADELINE KAHN
BLAZING SADDLES (1974)

LISA CAROL FREMONT
GRACE KELLY
REAR WINDOW (1954)

LORELEI LEE
MARILYN MONROE
GENTLEMEN PREFER BLONDES (1953)

LOUISE
SUSAN SARANDON
THELMA & LOUISE (1991)

LING WOO
LUCY LIU
ALLY MCBEAL (1997-2002)

LULA
LAURA DERN
WILD AT HEART (1990)

LUPE LAMORA
TALISA SOTO
LICENSE TO KILL (1989)

License to Kill
During the climax, Bond does his Indiana Jones stunt (i.e., hanging from the bottom of the truck) when Sanchez shoots at him. The ricocheting bullets play the Bond theme as they hit the truck.

LYDIA BRENNER
JESSICA TANDY
THE BIRDS (1963)

The Birds
The movie has absolutely no musical score.

LYNN BRACKEN
KIM BASINGER
L.A. CONFIDENTIAL (1997)

MAGGIE RICE
MEG RYAN
CITY OF ANGELS (1998)

MALLORY KNOX
JULIETTE LEWIS
NATURAL BORN KILLERS (1994)

MARGARET "HOTLIPS" HOULIHAN
LORETTA SWIT
M*A*S*H (1972-1983)

MARGE GUNDERSON
FRANCES MCDORMAND
FARGO (1996)

MARGO CHANNING
BETTE DAVIS
ALL ABOUT EVE (1950)

MARIA
NATALIE WOOD
WEST SIDE STORY (1961)

MARLA SINGER
HELENA BONHAM CARTER
FIGHT CLUB (1999)

Fight Club

There is a quick flash at the end of the movie that is a single frame of a large penis—just like the kind Tyler inserts into family films.

MARY GOODNIGHT
BRITT EKLAND
THE MAN WITH THE GOLDEN GUN (1974)

MARY HATCH BAILEY
DONNA REED
IT'S A WONDERFUL LIFE (1946)

It´s a Wonderful Life

There is a loud crash in the scene where Uncle Billy is drunk and leaves George. Uncle Billy says, "I'm okay, I'm okay". Actually, it was a crew member who made the noise, but Thomas Mitchell, who played Uncle Billy, improvised and said "I'm okay", making it seem like he made the crash. The scene was left in.

MARY POPPINS
JULIE ANDREWS
MARY POPPINS (1964)

MARYLIN REXROTH
CATHERINE ZETA-JONES
INTOLERABLE CRUELTY (2003)

MAY DAY
GRACE JONES
A VIEW TO A KILL (1985)

MIDNIGHT FRANKLIN
JAYNE MANSFIELD
TOO HOT TO HANDLE (1960)

MIRANDA HOBBES
CYNTHIA NIXON
SEX AND THE CITY (1998-2004)

MISS MONEYPENNY
LOIS MAXWELL
ALL BOND MOVIES, UNTIL
A VIEW TO A KILL (1985)

MOLLY MIDDLETON
SHIRLEY TEMPLE
OUR LITTLE GIRL (1935)

MONICA GELLER BING
COURTENEY COX
FRIENDS (1994-2004)

MORTICIA ADDAMS
ANJELICA HUSTON
THE ADDAMS FAMILY (1991)

MRS. ROBINSON
ANNE BANCROFT
THE GRADUATE (1967)

The Graduate
In the scene where Elaine is up in Benjamin's room at Berkeley, one of the other boy is a very young Richard Dreyfus.

NATALIE COOK
CAMERON DIAZ
CHARLIE'S ANGELS (2000)

Charlie's Angels
The house Drew Barrymore fell into is the same house they used in *E.T., The Extraterrestrial,* which she co-stared in.

NELLE PORTER
PORTIA DE ROSSI
ALLY MCBEAL (1997-2002)

NORA TEMPLE
LAUREN BACALL
KEY LARGO (1948)

NORMA DESMOND
GLORIA SWANSON
SUNSET BOULEVARD (1950)

O-REN ISHII
LUCY LIU
KILL BILL: VOL. 1 (2003)

PEGGY VAN ALDEN
JUDY TYLER
JAILHOUSE ROCK (1957)

PENELOPE DAY
SHIRLEY TEMPLE
NOW AND FOREVER (1934)

PENELOPE LIGHTFEATHER
BRIGITTE BARDOT
AGENT 38-24-36 (1964)

PENNY LANE
KATE HUDSON
ALMOST FAMOUS (2000)

PHOEBE BUFFAY
LISA KUDROW
FRIENDS (1994-2004)

PRINCESS LEIA ORGANA
CARRIE FISHER
STAR WARS (1977)

Star Wars
Harrison Ford was just a builder on the set of *Star Wars* until
George Lucas asked him to read for the part of Han Solo.

PUSSY GALORE
HONOR BLACKMAN
GOLDFINGER (1964)

RACHEL GREEN
JENNIFER ANISTON
FRIENDS (1994-2004)

RAQUEL OCHMONEK
LIZ SHERIDAN
ALF (1986-1990)

REGAN TERESA MACNEIL
LINDA BLAIR
THE EXORCIST (1973)

The Exorcist

To achieve the frozen breath effect in Regan's room, the entire room was refrigerated. Actress Linda Blair, who wore only a thin nightgown, says that to this day she cannot stand cold.

Mercedes McCambridge, who played the voice of the demon, smoked cigarettes, ate raw eggs, and tied herself to a chair to create the anguished cry.

RIPLEY
SIGOURNEY WEAVER
ALIEN (1979)

Alien

The original script was written with characters only identified by their surnames, that is, of indeterminate sex. It came as a surprise to the producers when the "tough guy" hero of the story (Ripley) was cast as a woman. It wasn't until *Aliens*, the sequel to *Alien*, that it is revealed her first name is Ellen.

RITA MARLOWE
JAYNE MANSFIELD
WILL SUCCESS SPOIL ROCK HUNTER? (1957)

ROSE DEWITT BUKATER
KATE WINSLET
TITANIC (1997)

Titanic
Many of the extras in this film were well-known Hollywood stars. For example, as the Titanic sinks, a dark-haired man being pulled by the current at the base of the grand statue is famed comedian Adam Sandler. After the ship has sunk and the lifeboats turn around to look for any survivors, one of the dead people in the water is Harrison Ford. Bruce Willis also has a brief cameo during the Irish party in third class.

ROSEANNE CONNER
ROSEANNE
ROSEANNE (1988-1997)

SALLY ALBRIGHT
MEG RYAN
WHEN HARRY MET SALLY... (1989)

SALLY BOWLES
LIZA MINNELLI
CABARET (1972)

SAMANTHA JONES
KIM CATTRALL
SEX AND THE CITY (1998-2004)

SAMTHANA JOSEPHINE "SAMMY JO" DEAN REECE CARRINGTON FALLMONT
HEATHER LOCKLEAR
DYNASTY (1981-1989)

SANDY OLSSON
OLIVIA NEWTON-JOHN
GREASE (1978)

Grease
One of the waitresses at the ice cream bar
is played by John Travolta's sister.

SARAH CONNOR
LINDA HAMILTON
THE TERMINATOR (1984)

SARAH TOBIAS
JODIE FOSTER
THE ACCUSED (1988)

SATINE
NICOLE KIDMAN
MOULIN ROUGE! (2001)

Moulin Rouge
Kylie Minogue plays the Green Fairy that flys out
of the liquor bottle and sings.

SCARLETT O'HARA
VIVIEN LEIGH
GONE WITH THE WIND (1939)

Gone With the Wind
The movie was fined $5,000 for saying the word "damn".
At the time, it was a crime to use swear words in a movie.

SCHATZE PAGE
LAUREN BACALL
HOW TO MARRY A MILLIONAIRE (1953)

SERA
ELISABETH SHUE
LEAVING LAS VEGAS (1995)

SHEILA
BEVERLY D'ANGELO
HAIR (1979)

SHENZI (VOICE)
WHOOPI GOLDBERG
THE LION KING (1994)

SHIRLEY FEENEY-MEANEY
CINDY WILLIAMS
LAVERNE & SHIRLEY (1976)

SIDNEY PRESCOTT
NEVE CAMPBELL
SCREAM (1996)

Scream
Director Wes Craven, as the janitor, is dressed like the infamous Freddy Krueger; that's why his name is Fred. This is a direct tribute to the *Nightmare on Elm Street* films, which Craven also directed.

SONIA KOVAC
LAUREN BACALL
BRIGHT LEAF (1950)

STORM/
ORORO MUNROE
HALLE BERRY
X-MEN (2000)

X-Men
When Senator Kelly comes out of the water at the beach, he approaches a hot dog vendor. The vendor is Stan Lee, the creator of *X-Men*.

SUE ELLEN SHEPARD EWING
LINDA GRAY
DALLAS [1978-1991]

SUGAR KANE KOWALCZYK
MARILYN MONROE
SOME LIKE IT HOT [1959]

Some Like it Hot
Director Billy Wilder was so frustrated with Marilyn Monroe
forgetting her lines that he posted them at numerous spots
on the set -including inside a dresser drawer.

SUKI YAKI
AKIKO WAKABAYASHI
WHAT'S UP, TIGER LILY? [1966]

SUKIE RIDGEMONT
MICHELLE PFEIFFER
THE WITCHES OF EASTWICK (1987)

SYLVIA
ANITA EKBERG
LA DOLCE VITA (1960)

TESS MILLAY
JOANNE DRU
RED RIVER (1948)

THELMA
GEENA DAVIS
THELMA & LOUISE (1991)

TINKERBELL
JULIA ROBERTS
HOOK (1991)

Hook

Dustin Hoffman's three children make appearances in the movie. Maxwell Hoffman plays the role of "5-Year-Old Peter Pan", Rebecca Hoffman plays "Jane in Play" and Jake Hoffman plays "Little League Player (as Jacob Hoffman)"

TRINITY
CARRIE-ANNE MOSS
THE MATRIX (1999)

The Matrix

The camera crew all wore white so they wouldn't be reflected in the actor's sunglasses.

VELVET BROWN
ELISABETH TAYLOR
NATIONAL VELVET (1944)

VERDELL
JILL THE DOG
AS GOOD AS IT GETS (1997)

VICKI VALE
KIM BASINGER
BATMAN (1989)

VIOLA DE LESSEPS
GWYNETH PALTROW
SHAKESPEARE IN LOVE (1998)

VIVIAN "VIV" WARD
JULIA ROBERTS
PRETTY WOMAN (1990)

WANDA GERSHWITZ
JAMIE LEE CURTIS
A FISH CALLED WANDA (1988)

WEDNESDAY ADDAMS
CHRISTINA RICCI
THE ADDAMS FAMILY (1991)

WENDY TORRANCE
SHELLEY DUVALL
THE SHINING (1980)

WILMA FLINTSTONE
ELIZABETH PERKINS
THE FLINTSTONES (1994)

XENIA ONATOPP
FAMKE JANSSEN
GOLDENEYE (1995)

Index

MORE FROM NICOTEXT

The Pet Cookbook
Have your best friend for dinner
91-974883-4-8
Humor/Cooking

Domesticated Delicacies from Around the World

On a global scale, one man's pet is another man's supper, and this wild cookbook shares the best recipes from around the world on how to prepare those delectable little dishes from the domesticated animal kingdom. Scorpion Soup with a Sting, Pony 'n' Pepperoni Pizza, Parrot Piroge, and Goldfish Te Wrap are just a few samples of the eclectic world cuisine within. Decidedly not for vegetarians.

*No animals were hurt during the making of this book.

The Pornstar Name Book - The Dirtiest Names on the Planet
91-974883-2-1
Humor
September 2005

The coolest hardcore names in the business

Rename your lover, or your pet, your car or the stupid person at work in the nom de plume of a porns Here are the coolest names in the entire X-rated business, along with tons of fun porn and sex trivia. Read it for at laugh or get ideas for creating your own dirty nicknames. The Pornstar Name Book also contains a music CD, Porn Lounge Music, which is perfect to put you in the right mood for doing wha porn stars are paid to do.

The Bible About My Friends
91-974396-4-9
Humor
September 2005

Things You've Always Wanted to Know But Have Been too Scared to Ask
This book is about your friends and everything you've always wanted to know about them --
featuring simple, funny, entertaining questions for your very best friends to answer. These are
questions about who they really are, about their dreams, hopes, plans and, not least, their secrets
You know, things you've always wanted to know about them but have been to scared to ask.
This book will bring out the worst and the best about those you thought you knew.
Together you will laugh at the answers for years to come. That is, if you're still friends...

MORE FROM NICOTEXT

CONFESSIONS
Shameful Secrets of Everyday People
91-974396-6-5
Humor

Eavesdropping in the Confessional

Like being a fly on the wall in any church confessional, these incredible real online admissions of people's darkest secrets are alternately disturbing, whimsical and hilarious. Sure to spark interesting conversations, this is the perfect therapeutic gift to share with friends and loved ones (and perhaps detested enemies, with certain confessions circled in red and "I know your secret" handwritten nearby).

BLA BLA - 600 Incredibly Useless Facts
Something to Talk About When You Have Nothing else to Say
91-974882-1-6
Humor

A Know-It-All's Handbook

Everyone needs something to blurt out during uncomfortable silences and ice-breaker moments. This fascinating handbook of hilarious, arcane and bizarre tidbits will make its bearer a hit at party conversation and trivia contests.

Cult MovieQuoteBook
91-974396-3-0
Humor/Film

A Film Buff's Dictionary of Classic Lines

Over 700 memorable, provocative, hilarious and thought- provoking quotes fill this fascinating guide, a kind of dictionary for movie quote buffs. Going beyond the old standards such as "Here's Looking at You Kid," this handbook pulls quotes from a surprisingly eclectic variety of global cinematic gems, and will have even the most diehard movie buffs frantic to place the line with the film.

Dirty MovieQuoteBook
91-974396-9-X
Humor/Film

Saucy Sayings of Cinema

With over 700 saucy, sexy quotes from the funniest and most sordid films ever produced. A movie quiz game in a book. An excellent source of fresh pick-up or put-down lines, this titillating guide is sure to put anyone in the mood for love.